Into The Garden

An Adult Coloring Book

by

Kristina Boyd

For more art and updates
follow me on
instagram: kristina_boyd
facebook: KristinaBoydArt

all images copyright Kristina Boyd 2016

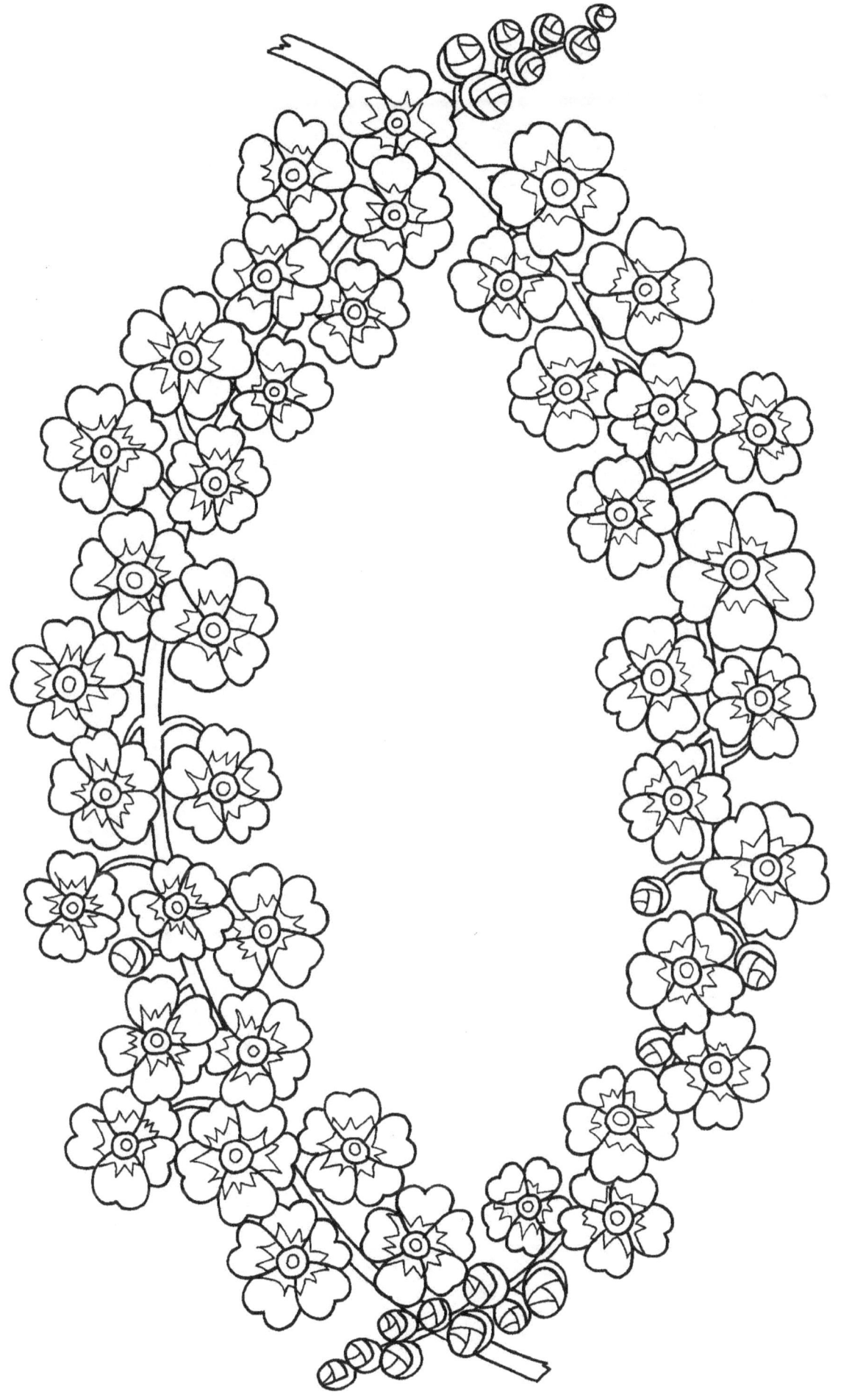

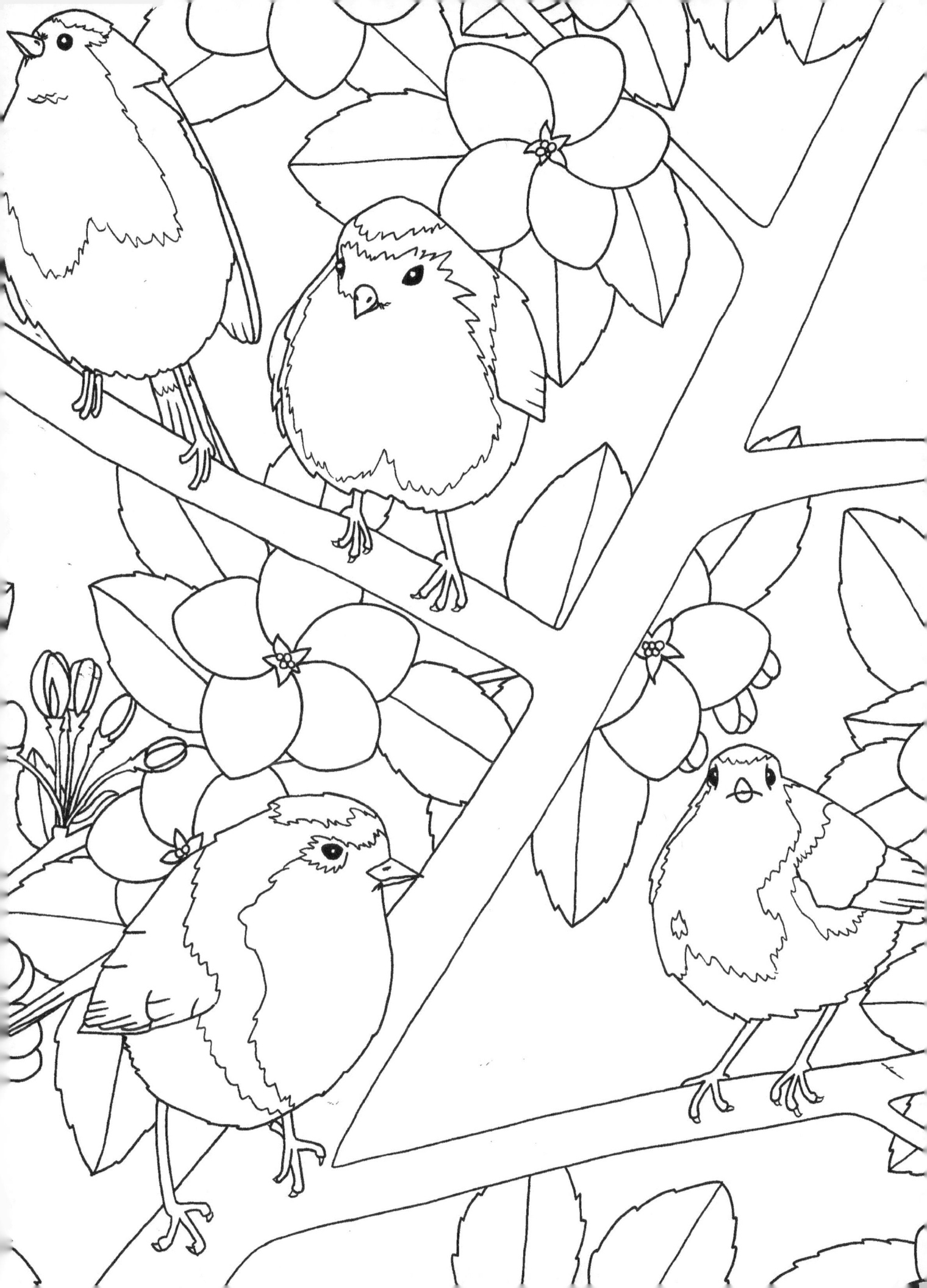

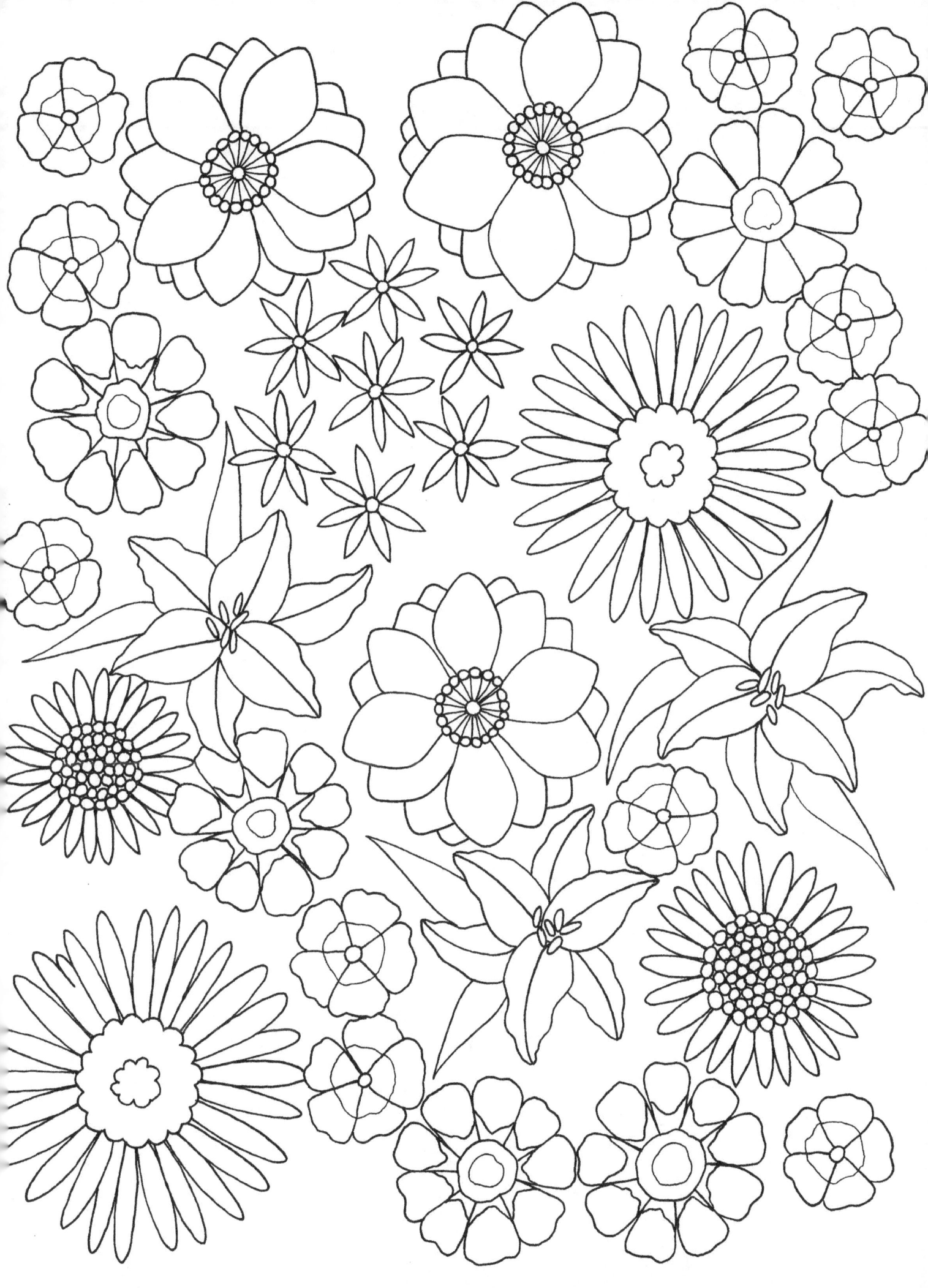

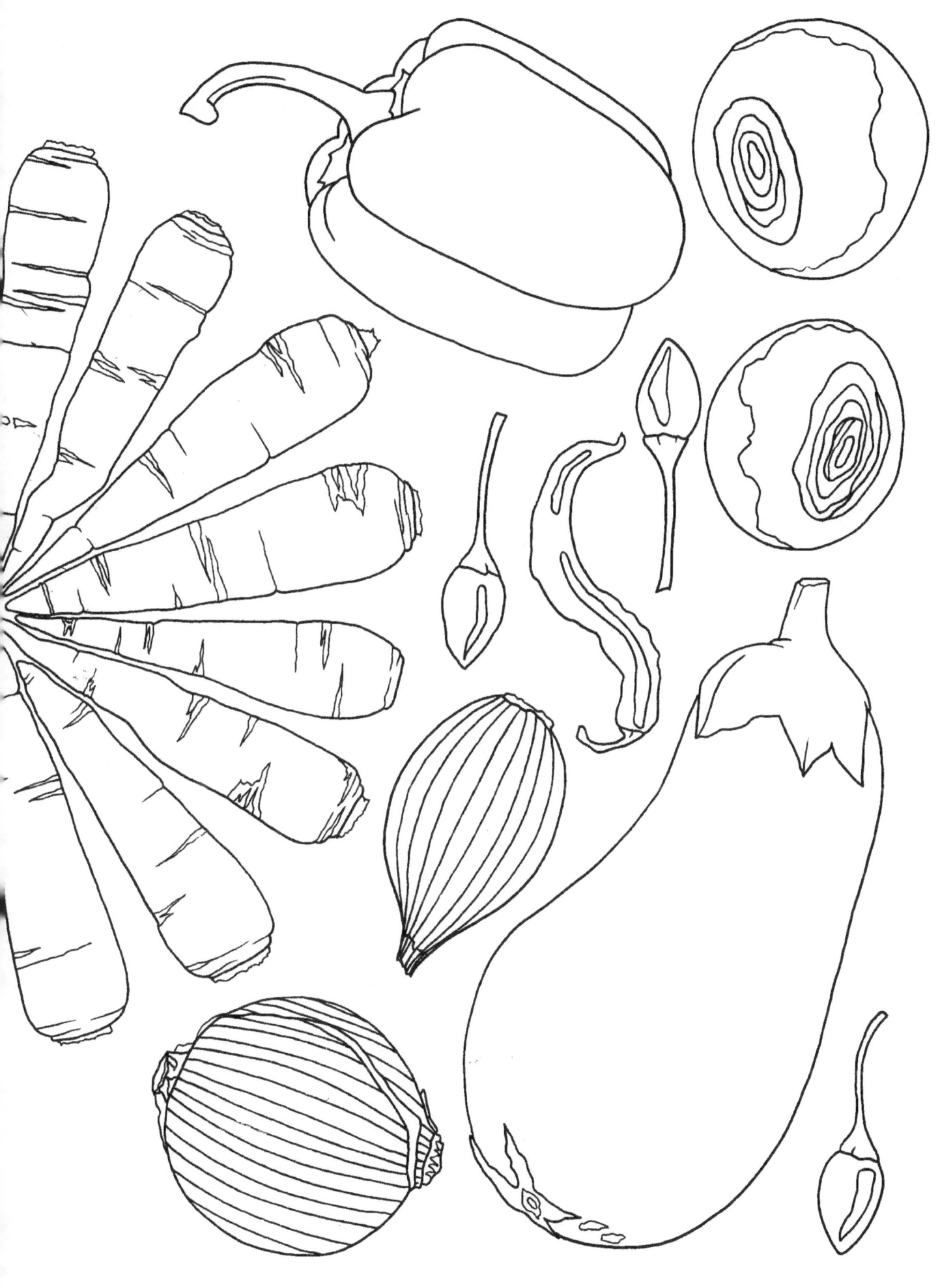

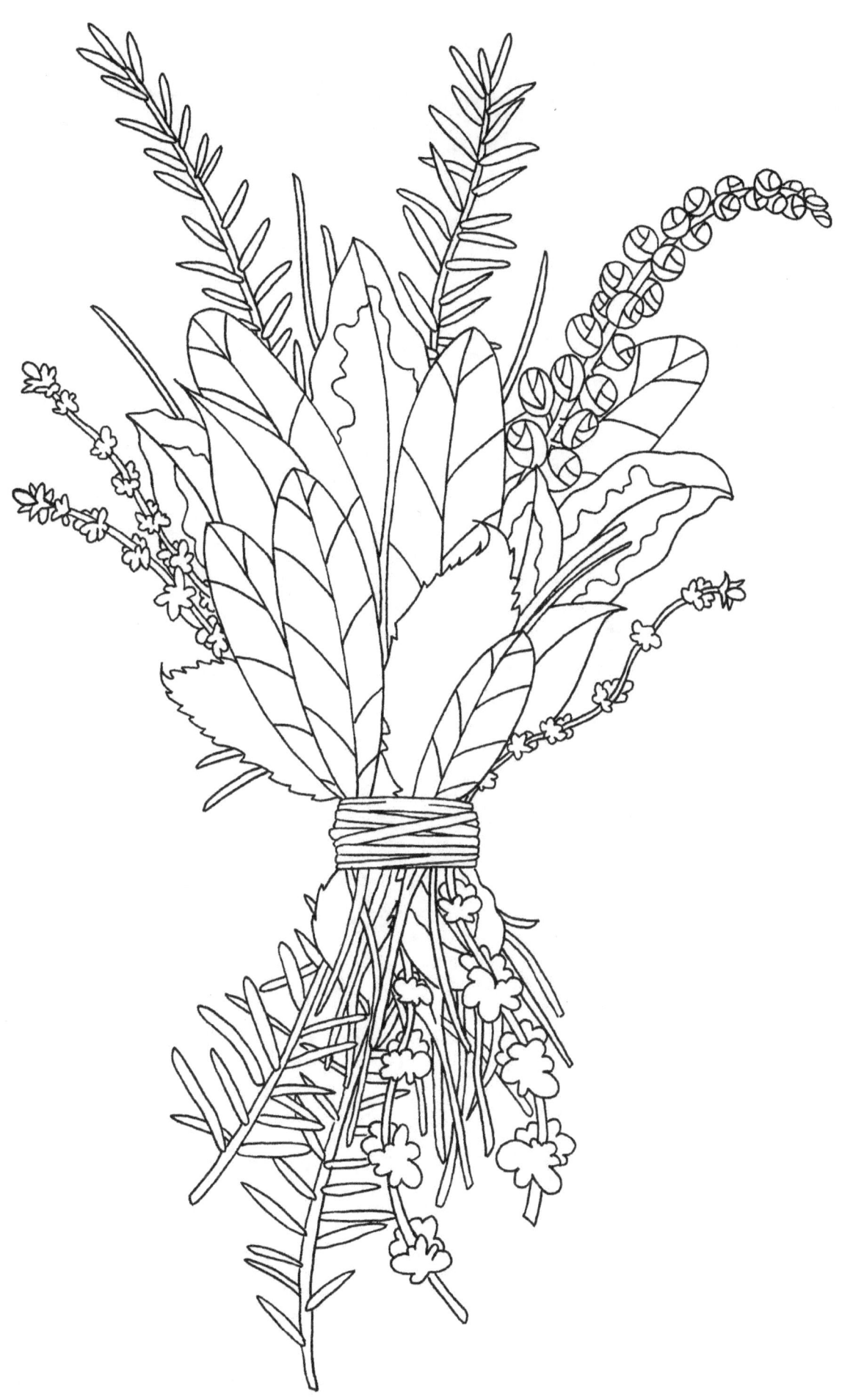

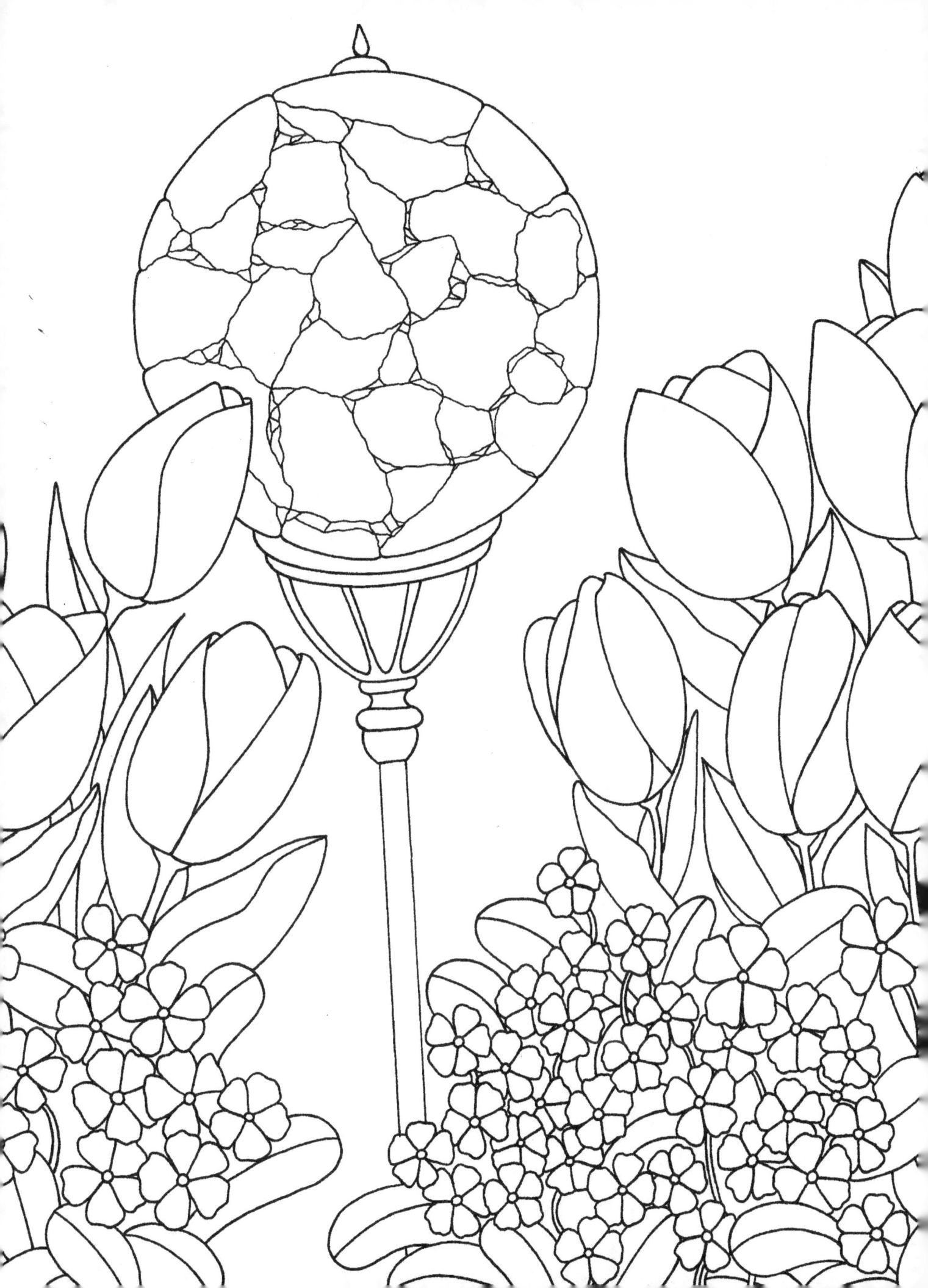

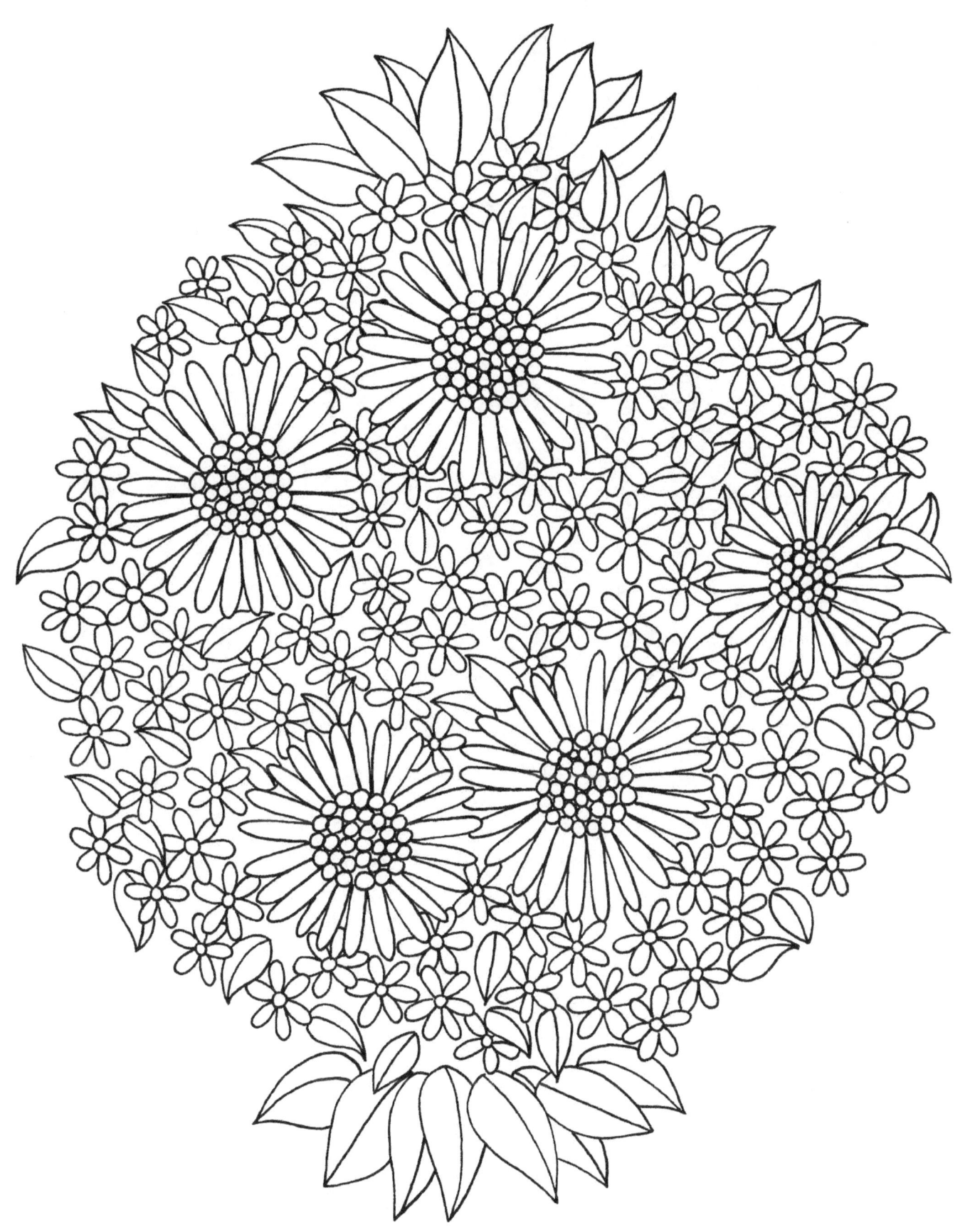

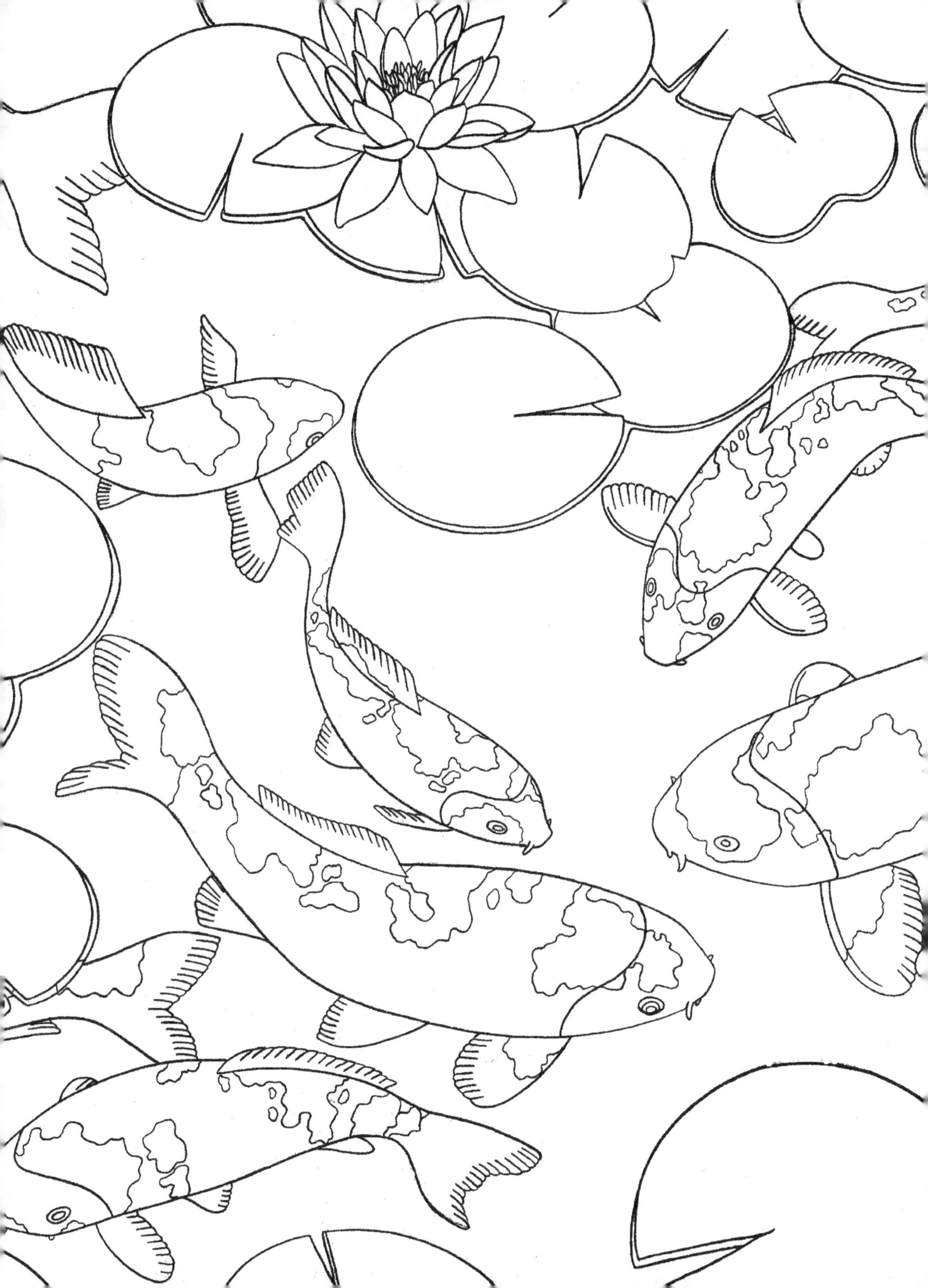

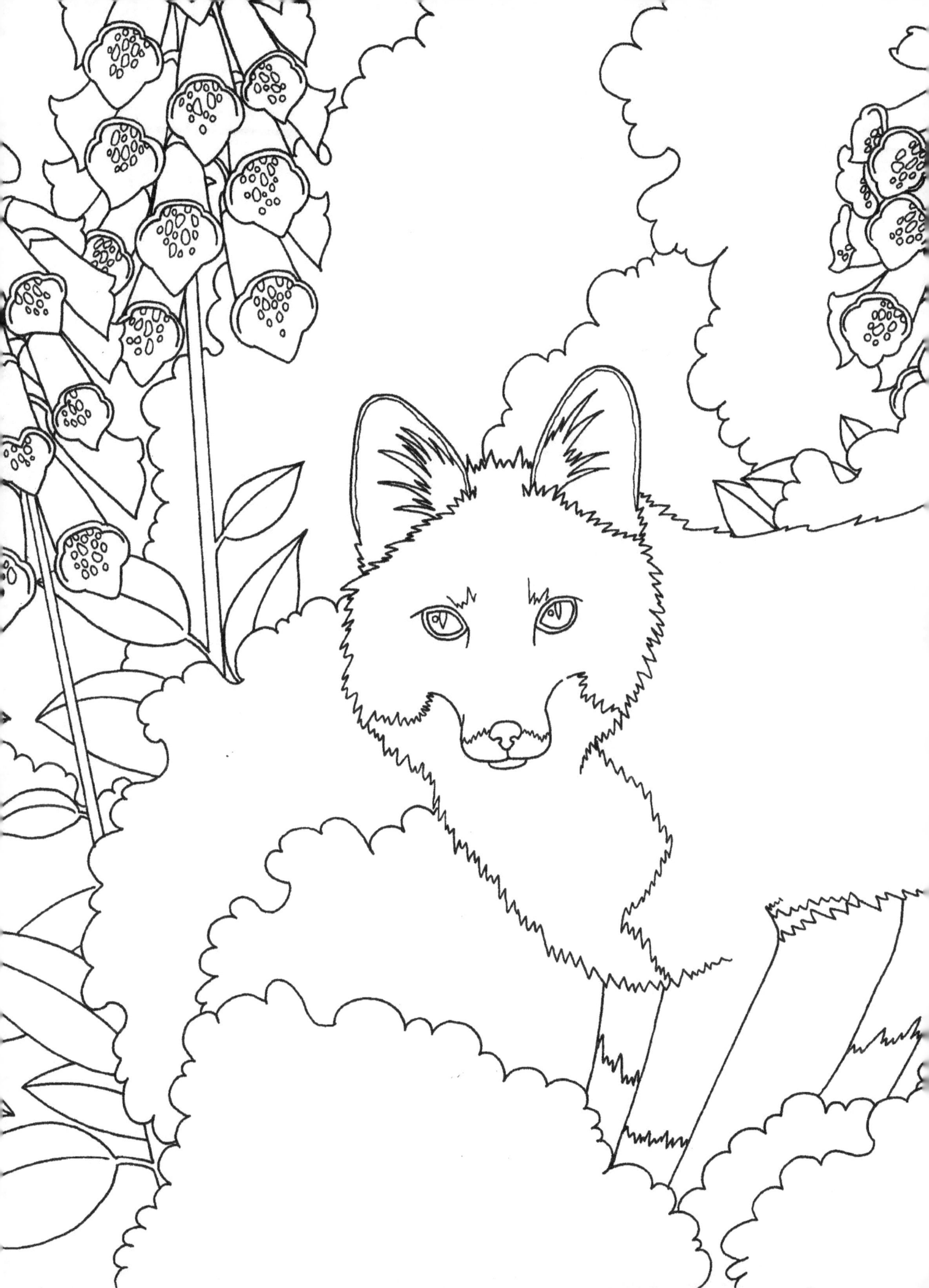

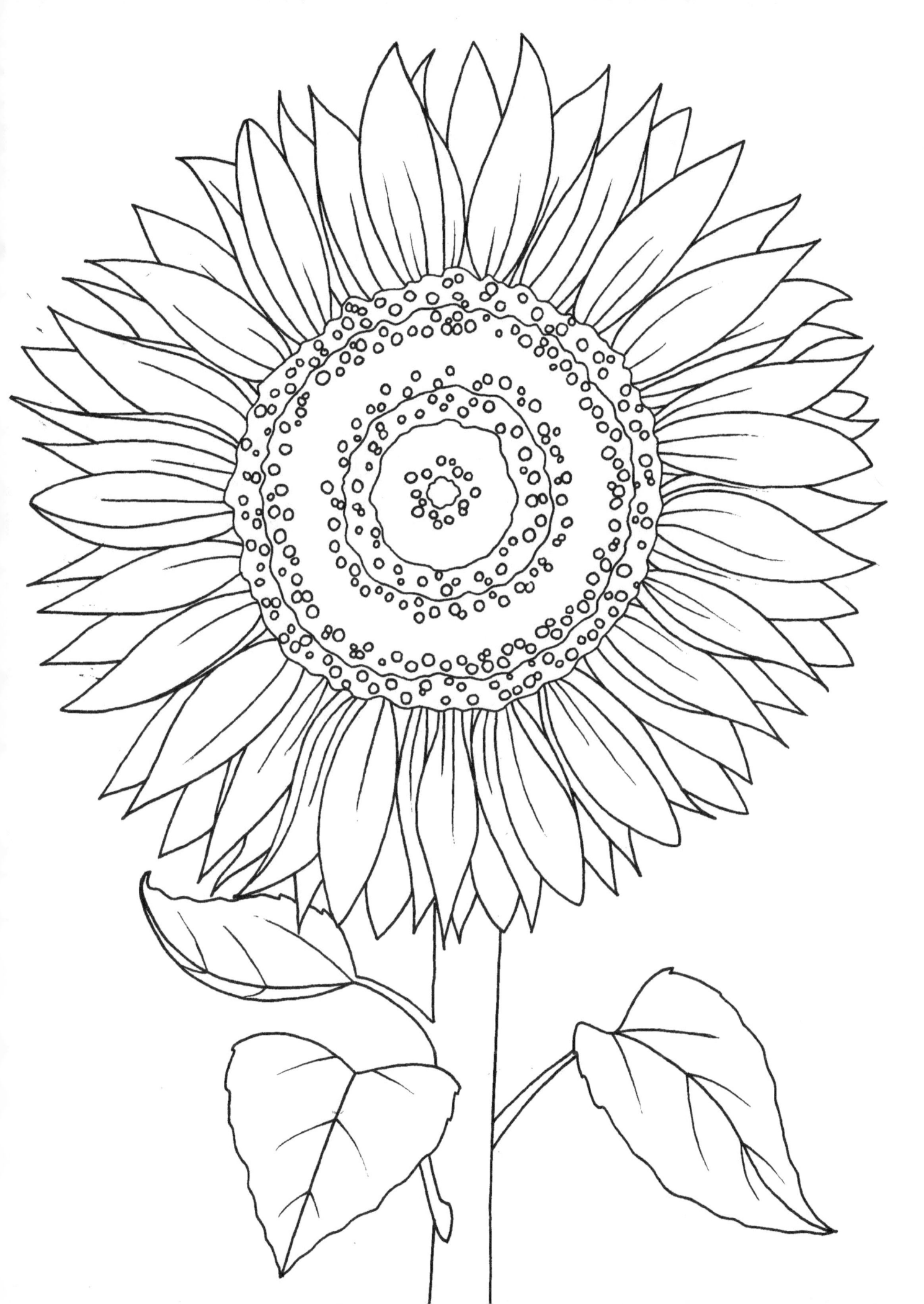

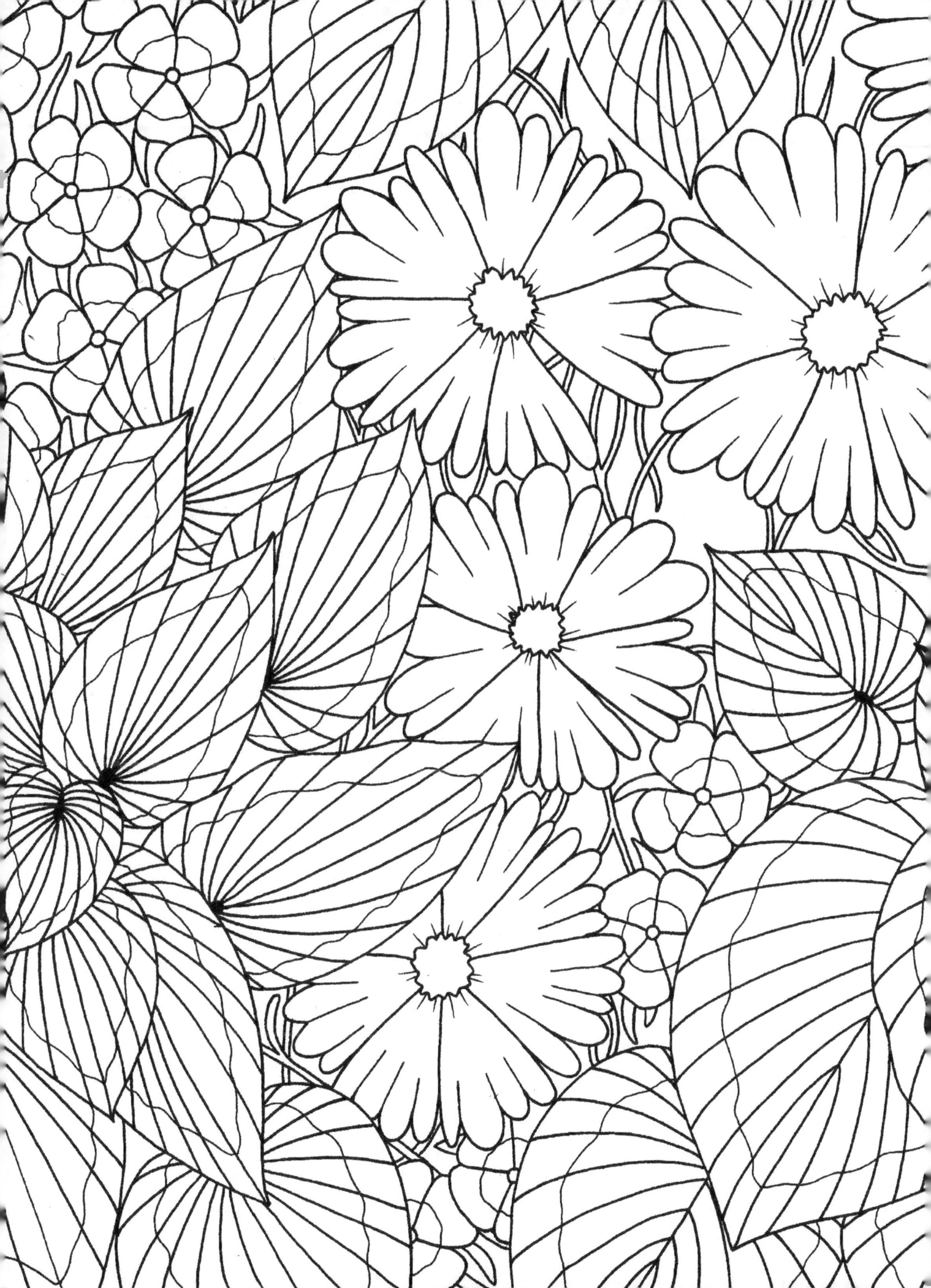

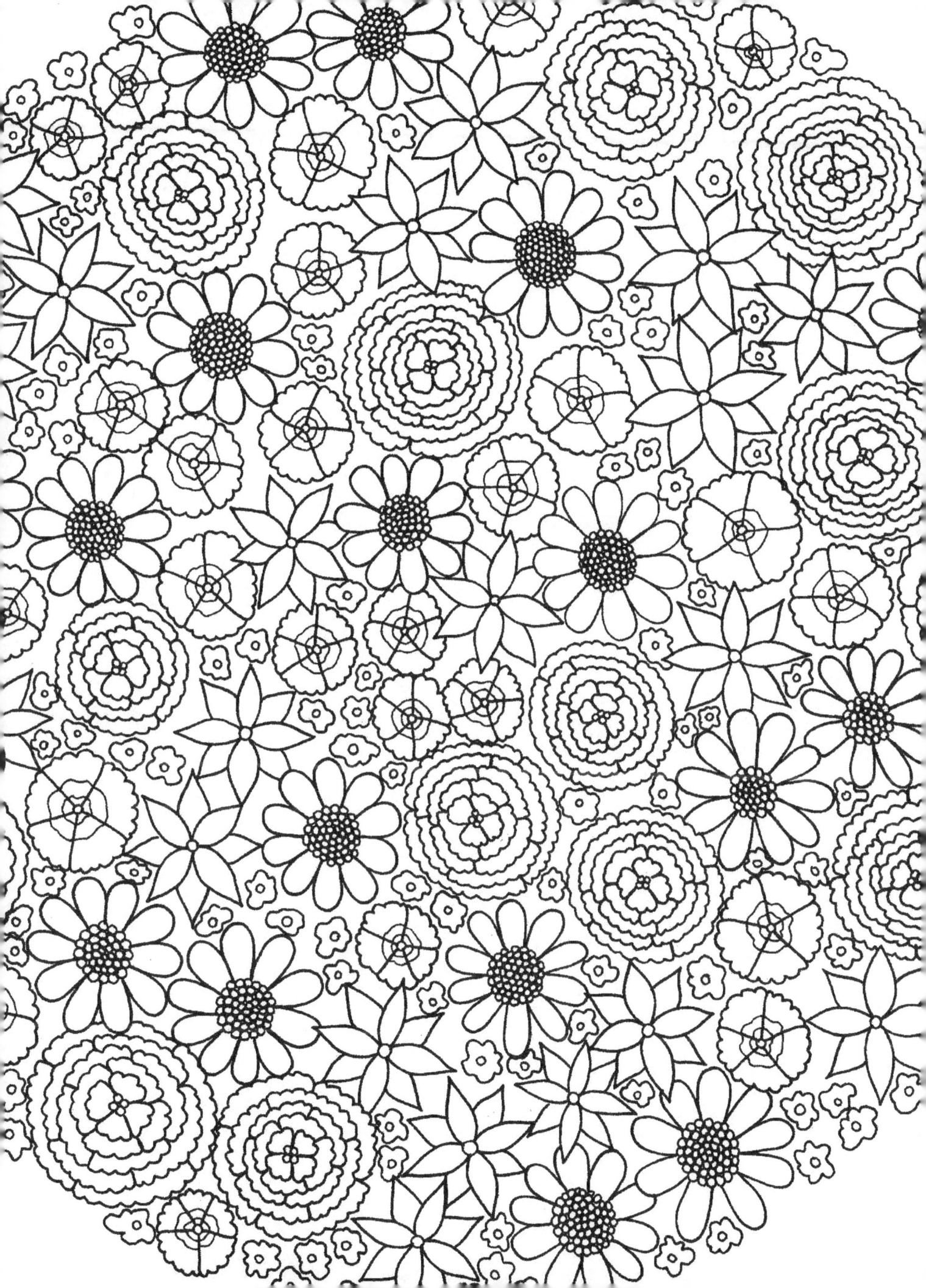

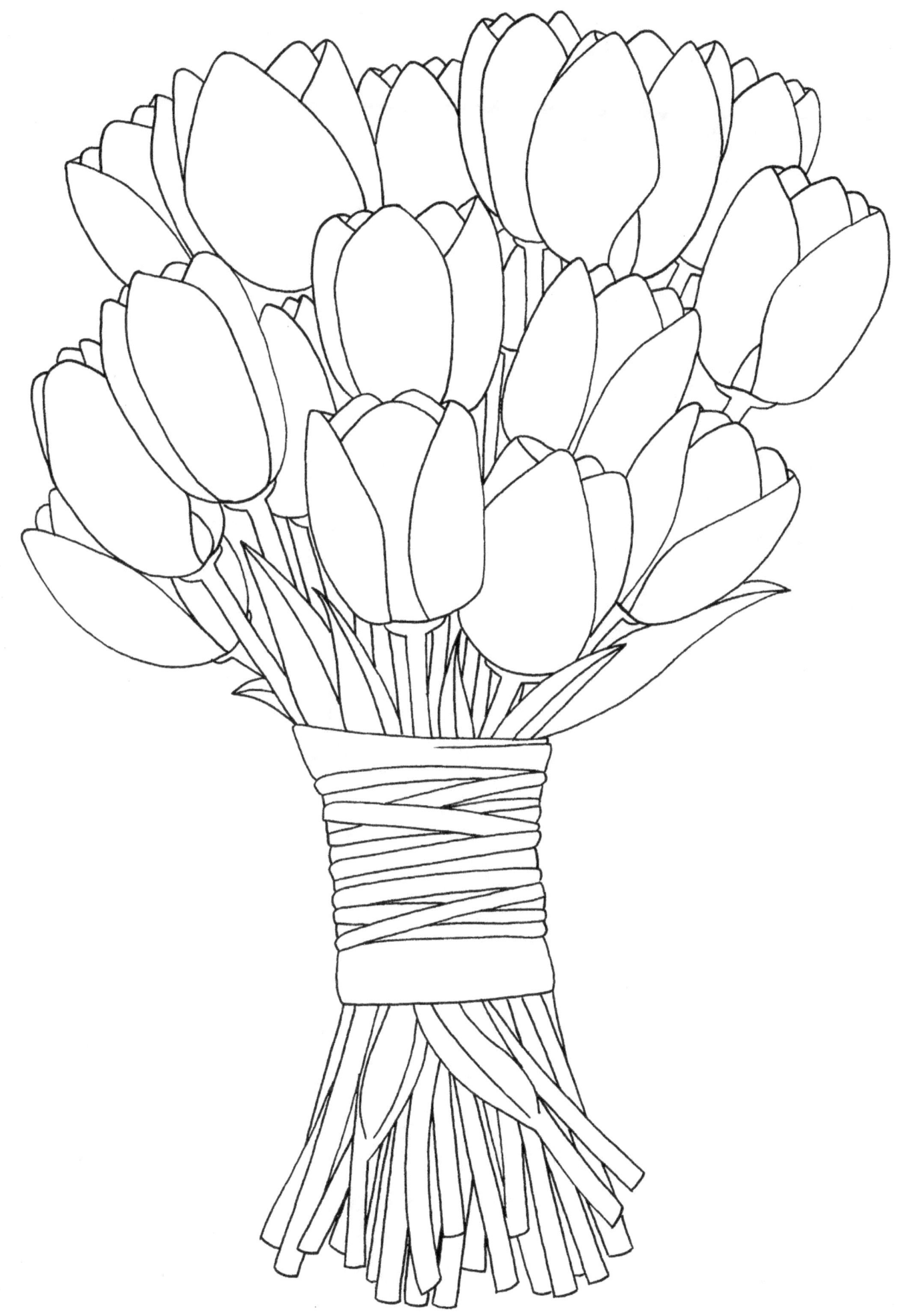

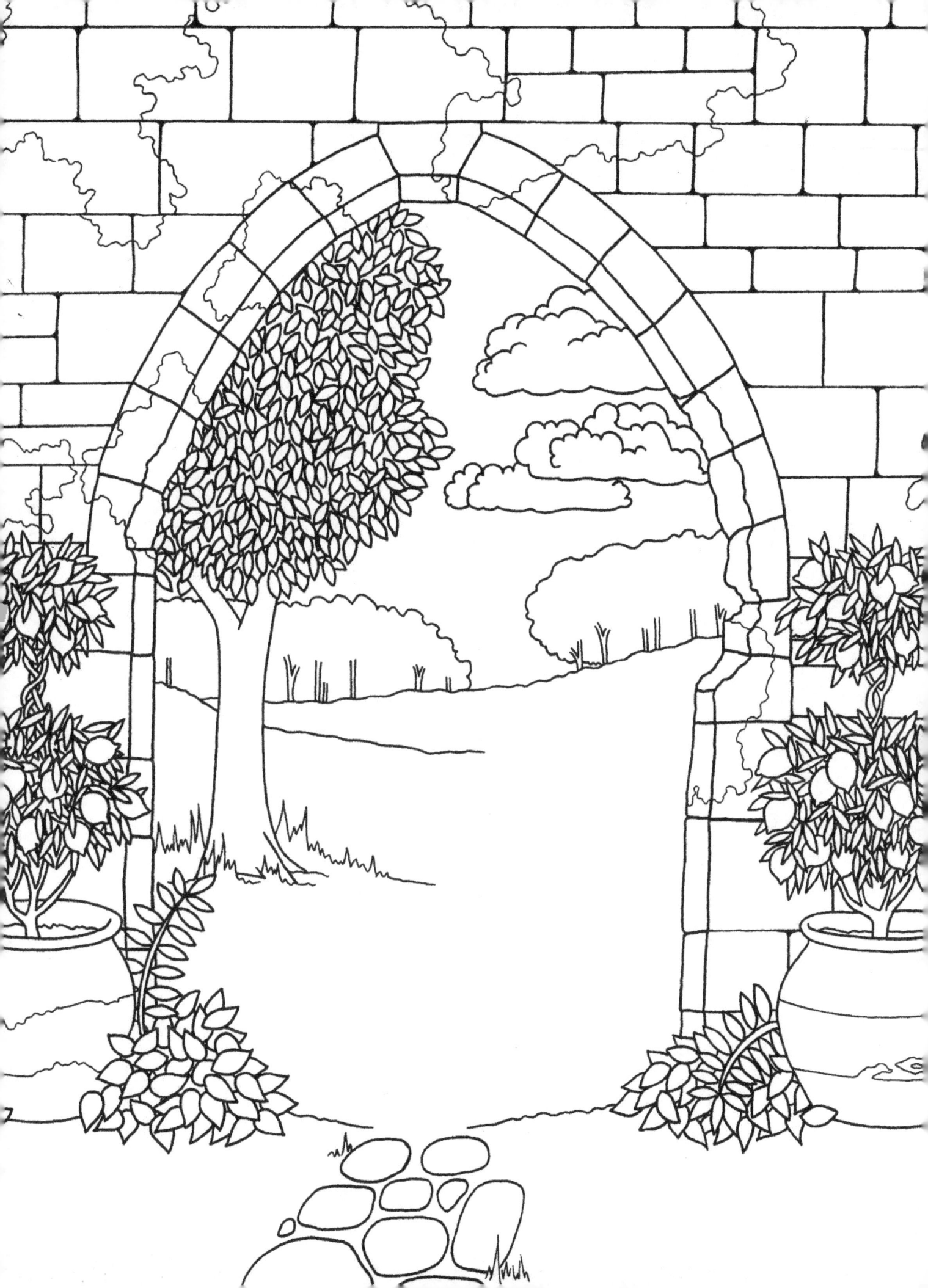

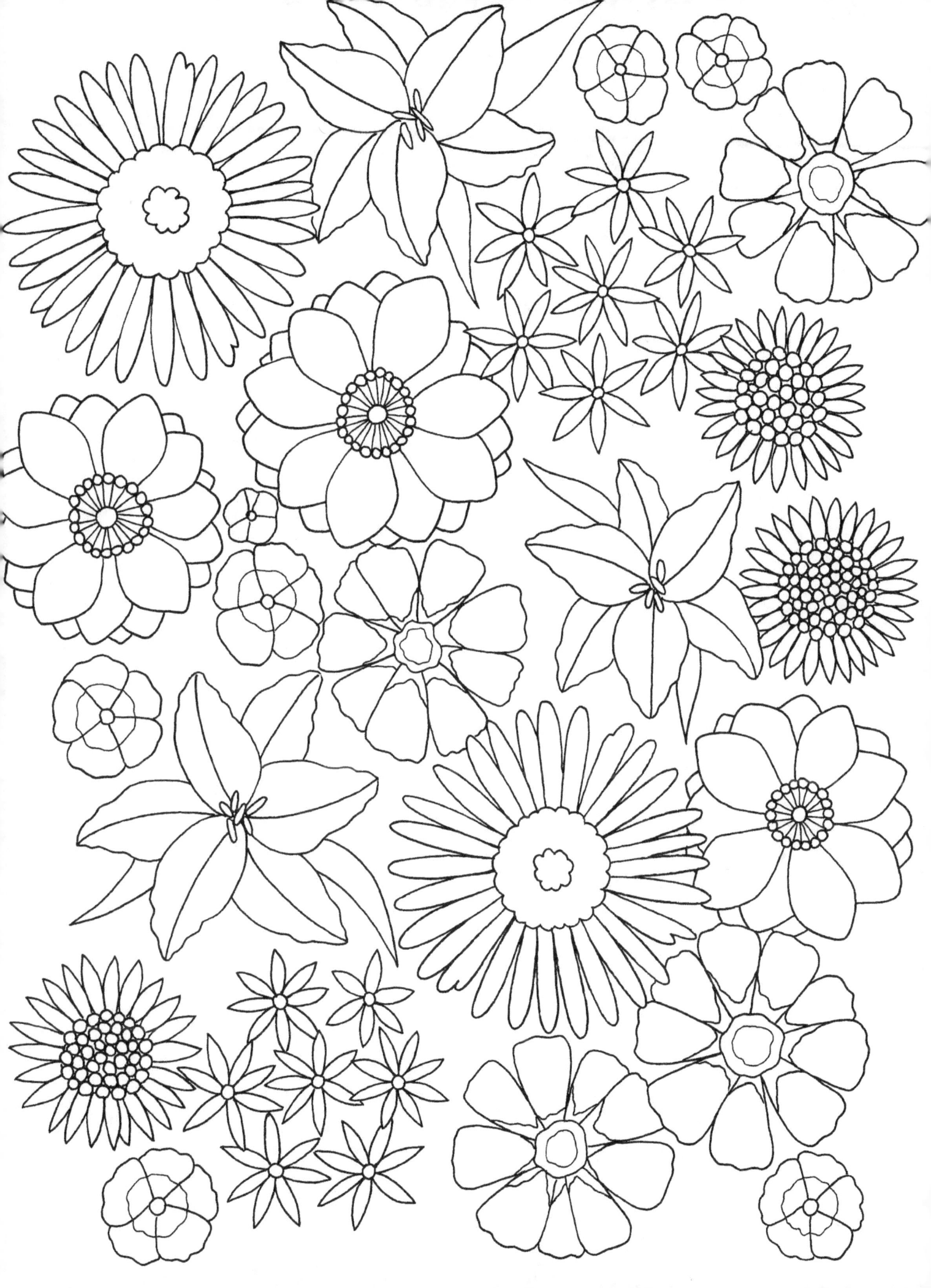

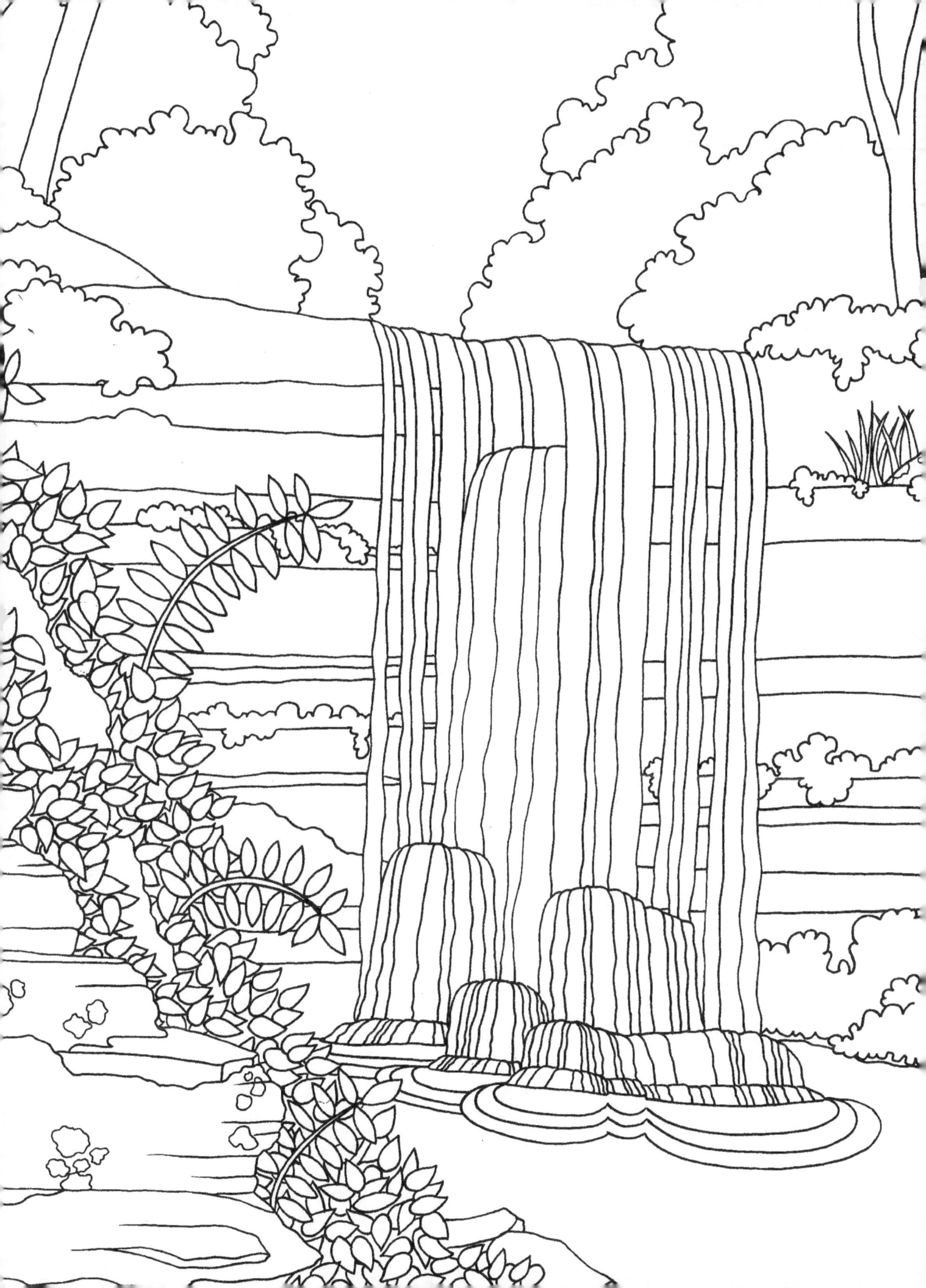

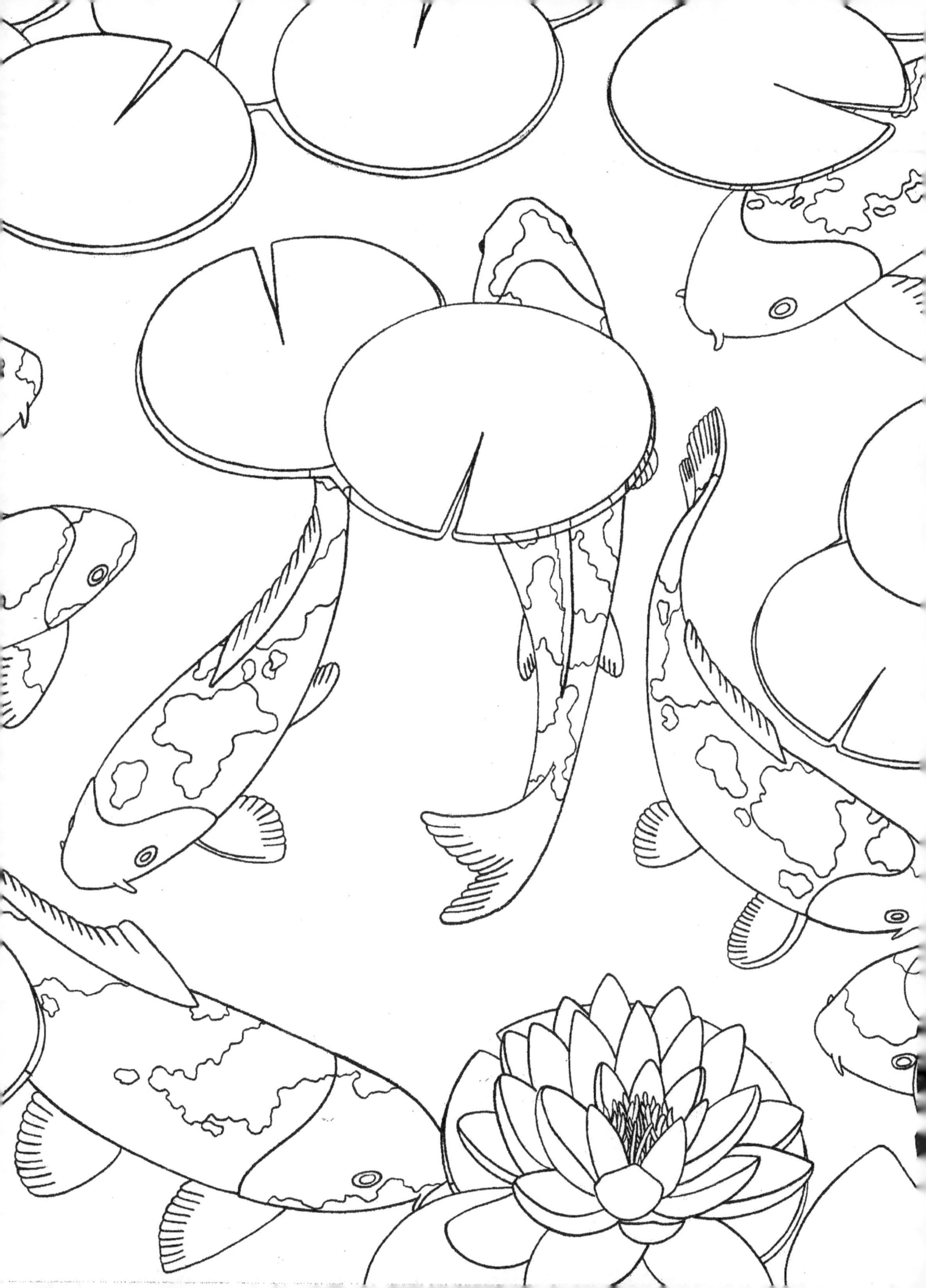

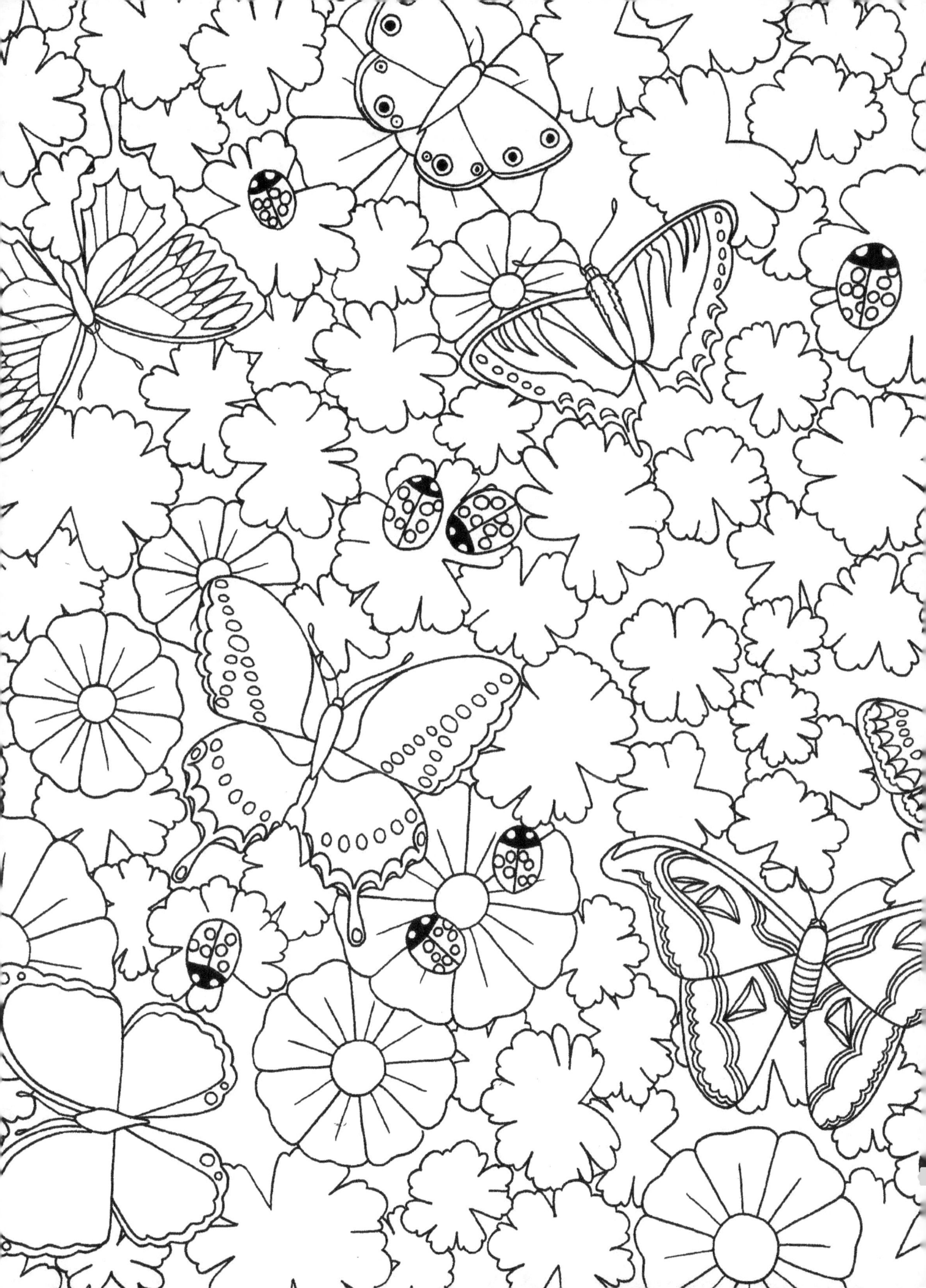

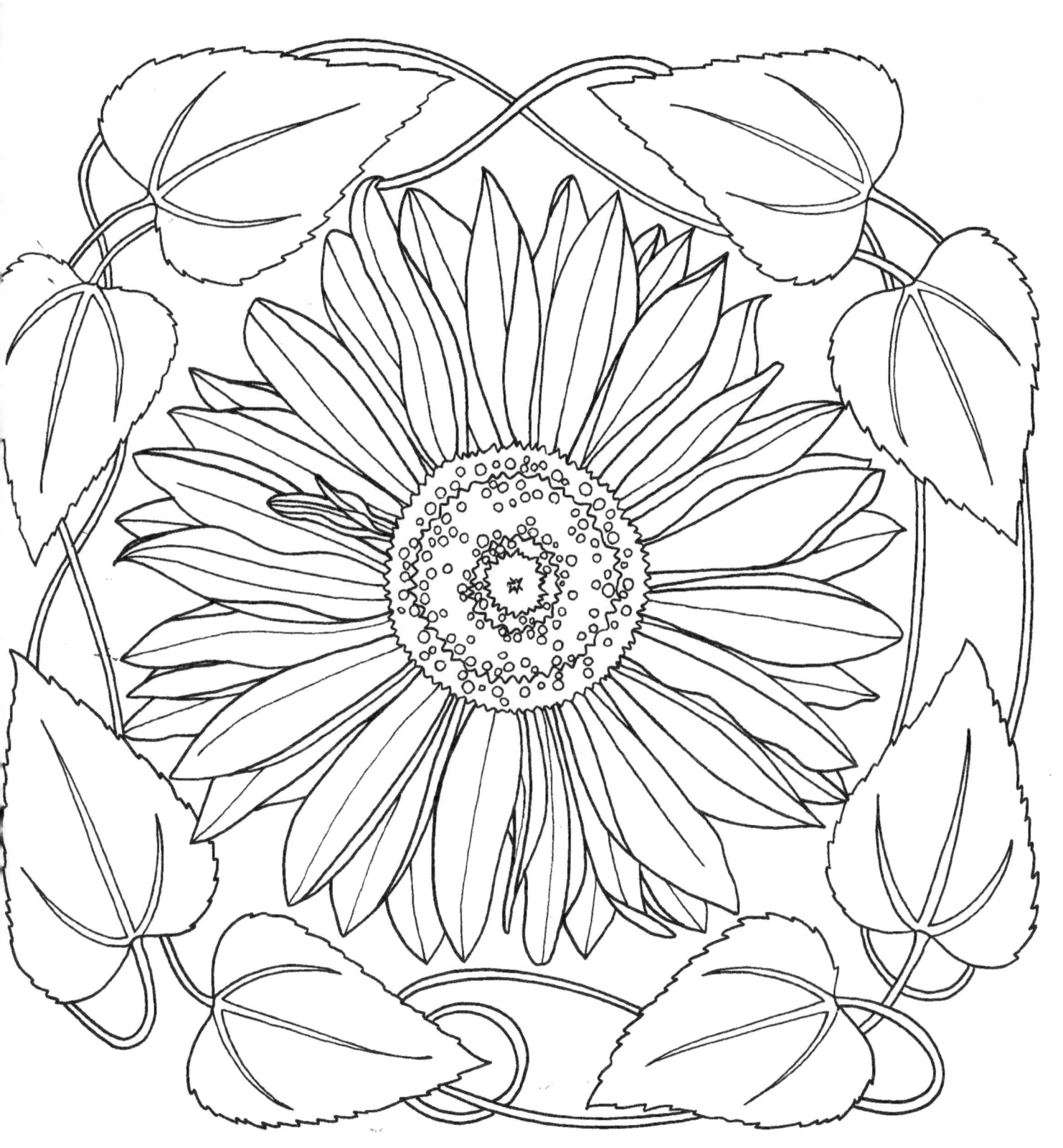

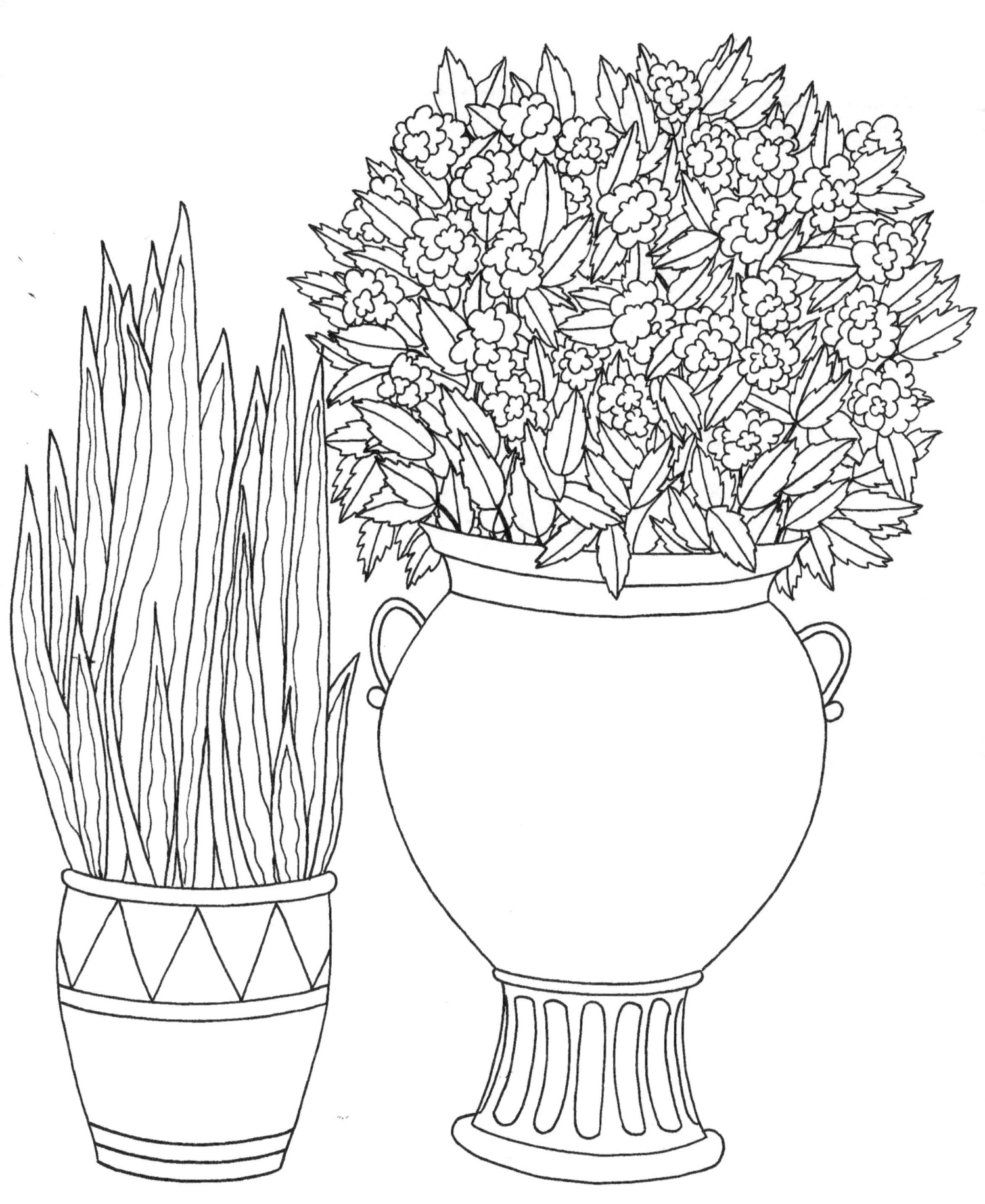

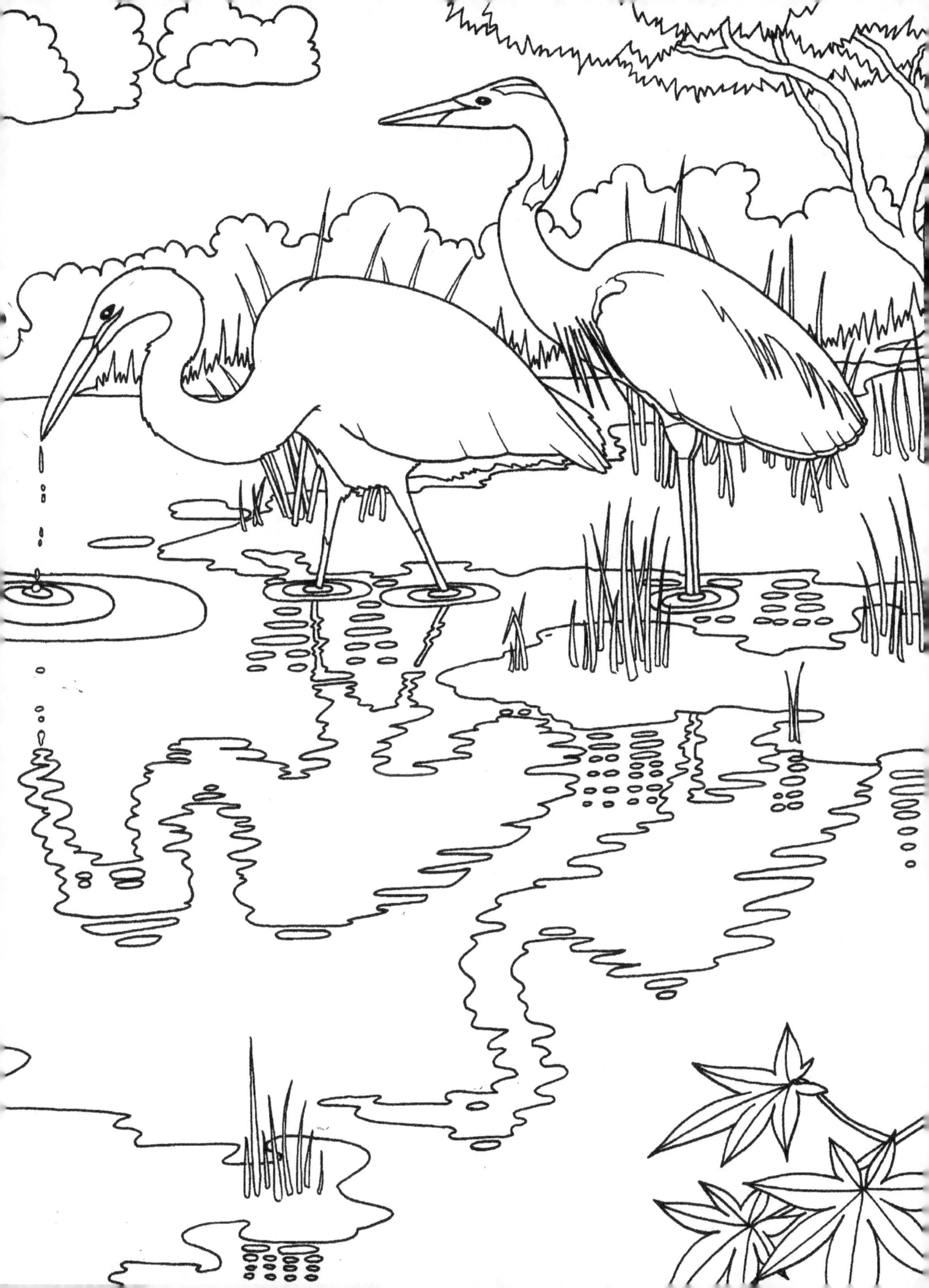

www.ingramcontent.com/pod-product-compliance
Lightning Source LLC
Chambersburg PA
CBHW080610190526
45169CB00007B/2959